FAITH IN THE CITY OF LONDON

Faith in the
City of London

NIKI GORICK

Contents

7 **Foreword** The Lord Mayor, William Russell

9 **Preface** Niki Gorick

10 **Introduction** Edward Lucie-Smith

14 **Preconceptions**

22 **The unexpected**

38 **Parish notes**

54 **Depth and breadth**

74 **Characters**

90 **Outside relations**

104 **Unique history celebrated**

116 **Let there be music**

134 **Venues for hire**

146 **Reaching out**

For Peter, Ria and Remi

Published in 2020 by
Unicorn, an imprint of Unicorn Publishing Group LLP
5 Newburgh Street, London W1F 7RG

www.unicornpublishing.org

A catalogue record for this book is available from the British Library

Text © Niki Gorick
Introductory Essay © Edward Lucie-Smith
Images © Niki Gorick

ISBN 978-1-912690-73-2

Designed by Ocky Murray
Printed in Slovenia by Latitude Press Ltd

Foreword

The Right Honourable The Lord Mayor
Alderman William Russell

THE CITY OF LONDON is primarily a place of business and finance but there are over 40 ancient churches within The Square Mile's boundaries and these add a distinct character to its daily life. They are a valuable contrast to the commercial pressures going on around them, offering respite in many forms and City workers of all faiths are able to find quiet spaces and spiritual support within their walls.

Often, these places of worship have direct links with the financial community going back hundreds of years through the Livery Companies but they have also moved with the times, updating services and inter-faith opportunities to suit contemporary workers' needs.

I am delighted that this book reveals and celebrates the City of London's very active and diverse spiritual life. It is an unheralded side to London's financial centre that deserves to be better known and appreciated.

Preface

Niki Gorick

FAITH AND MONEY-MAKING do not immediately strike one as easy bedfellows and yet why does The Square Mile, London's financial centre, have over forty churches and places of worship squeezed in between its towers of commerce? This unexpected concentration of both global businesses and churches intrigued me. Are these places of worship still functioning or are they are now just ancient buildings visited by a few tourists? What are contemporary clergy up to and how do they relate to the transitory, financial community surrounding them?

Curious, I started photographing the day-to-day workings of these beautiful buildings and discovered a hidden and surprisingly vibrant world of worship, stretching out into many different faiths. I had no idea that Romanian Orthodox Christians have been worshipping in an Anglican Church near St Paul's Cathedral for over 50 years, with 400 people still turning up for Sunday services, or that you can find donkeys processing through City streets on Palm Sunday, clergy having an egg-rolling competition down Fleet Street on Easter morning and livery company halls becoming Muslim prayer rooms during Friday lunchtimes. How had I been missing all this and more?

My own contact with religion had been limited, so my presence as a photographer was as a neutral but interested spectator. Initially, I was expecting to encounter some resistance, even refusal of my requests to capture clergy at work and photograph during services but once I had explained that my style of photography was very discreet, would not involve flash, lights or tripods or disrupt proceedings in any way, the welcome was usually very warm. It was then a case of building trust by making several visits to photograph. To begin with, I did feel as if I might be intruding on people's very personal acts of worship but I soon realised that respecting privacy at certain points in a service would still allow me to capture the essence of that particular event and faith.

This collection of photographs is the result of over 200 visits to most of the City's places of worship, as well as outside spiritual events. It has been a real privilege to have gained such access and I now have a completely different perspective on the City of London. Despite its reputation as a financially obsessed powerhouse, it has been fascinating to realise that it is also home to a whole host of spiritual goings-on and charismatic clergy. The Square Mile's combination of 2,000 years of history and a dynamic contemporary workforce is uniquely potent and creates a multi-layered interaction between faith and commerce within its tight geographical confines. I am hoping that my photographs will inspire you to push open some church doors for yourself and explore its spiritual nuances.

Introduction

Edward Lucie-Smith

THIS BOOK OFFERS a vision of the City of London qualified by the idea of 'Faith'. The City, as here presented, is not the vast metropolitan area also known as Greater London but the nucleus from which it has grown over many centuries. It occupies a legally defined area within the metropolis. In this respect, it is easy to say what is within the City or outside of it, although its boundaries are usually invisible to the visitor, to the inhabitants of the area concerned or to those who have daily business within it.

Powerful within this area, and crucial to its development, has been the Christian religion. This, like the City itself, has mutated over many centuries and is still, within this historical setting, undergoing processes of change. An important force in this change, in times past, was the Protestant Reformation of the sixteenth and seventeenth centuries. Through this, most of the important religious buildings then existing within the City came into the possession of the Church of England. Another force was the so-called Great Fire of London, which started in a bakery in Pudding Lane on 2 September 1666 and raged for four days. By that time, only one-fifth of London, as it then existed, remained standing. Virtually all the civic buildings were destroyed. So, too, were most of London's churches, among them St Paul's Cathedral.

As a result of the catastrophe, London was transformed physically. Crowded and disease-ridden medieval streets were swept away and a new metropolis emerged from the ashes.

Between 1675 and 1711 St Paul's Cathedral was rebuilt to designs by Sir Christopher Wren. The building Wren created now carries an inscription in the architect's memory: *Si monumentum requires, circumspice* ('If you seek [his] monument, look around you'). Wren was not, however, the only architect designing magnificent churches in the City at this time. Another architect of genius was Nicholas Hawksmoor (1661–1736), who began his career around 1679 as an assistant to Wren and who designed a number of important churches. In October 1711, Hawksmoor was appointed to a commission which was to build no fewer than fifty new churches in the Cities of London and Westminster. One of these, in the City of London, was St Mary Woolnoth (1714–29).

However, as this book makes evident, the Christian faith in its British Protestant form has been constantly evolving since the epoch of Wren and Hawksmoor. In December 2017, for example, the Rt Rev. Sarah Mullally became the first female Bishop of London, the 133rd person to hold this office. She ranks third in seniority within the Anglican church to the Archbishops of Canterbury and of York.

This is not the only evidence of modernity – or indeed of social change – that this book has to offer. What one sees here is how British society is evolving. It is clear that within the boundaries of the City of London, which is still – as it always has been – Britain's most commercial centre of commerce, a continuous evolution is in progress. The Church of England, represented as it is by many major

examples of sacred architecture, is part of this but not the sole part. The activity of human beings within the parameters of an increasingly complex modern society is even more important than what the surrounding historical monuments have to say. The images show us details of the religious life but always within a contemporary context. However traditional the setting, the emphasis is always on the participants of all generations living and reacting within that setting.

Some of the occasions represented are traditional. For example, there is an image from a City wedding, in which we see members of the Worshipful Company of Watermen and Lightermen standing on either side of the priest in charge of the ceremony, together with the groom's mother. The lady wears a bright red dress that exactly matches the uniforms of the Watermen, who are holding their ceremonial oars.

In another picture we see a Palm Sunday procession, led by a man with a donkey. Behind him there are some figures in surplices but he is wearing a cheerful, absolutely contemporary pullover. The message is that Faith remains absolutely relevant today. For a Harvest Festival at St Mary-at-Hill, Billingsgate fish merchants are pictured with a magnificent array of fish. Yet another tradition is that of egg-rolling. The congregation of St Bride's celebrates Easter with an early morning egg-rolling competition down Fleet Street. The winner is the person who manages to roll their egg the furthest, various possible obstacles notwithstanding.

Sometimes the focus slips back to a time before the Christian era. One illustration shows a Roman head of Mithras from a temple to the god discovered on the site of the London headquarters of the financial, software, data and media Bloomberg company. Founded in New York in 1981, this company is a major force in the modern City and typifies its vast international financial outreach. As the internet site for the London Mithraeum Bloomberg states: 'This anticipated new cultural hub showcases the ancient temple, a selection of the remarkable Roman artefacts found during the recent excavation, and a series of contemporary art commissions responding to one of the UK's most significant archaeological sites.'

At other times, the focus is on charity. On others, again, it is on contemporary art. A café in the church of St Mary Aldermary sells coffee and food, even during services, while St Mary-at-Hill hosts exhibitions of contemporary art.

Anglicans are not the only ones to celebrate the Christian faith within the boundaries of the City. Anglican churches on occasion play host to Christian believers of other denominations. One Anglican church that shelters another variant of the Christian creed is St Andrew by the Wardrobe, which every Sunday hosts a Eucharist service for the St Gregorios Indian Orthodox Church. Roman Catholic worship, long almost outlawed and practised in secret in small chapels, now flourishes openly at St Mary Moorfields. Congregants there are mostly non-residents in the City. Nevertheless, a number of them attend services daily. The Jewin Chapel offers a home to Presbyterianism, where the services are often in Welsh. The Welsh language is also used in Sunday services at St Benet's, which has functioned since 1954 as the Metropolitan Welsh Church. Romanian Orthodoxy flourishes at St Dunstan-in-the-West.

Non-Christian faiths also find a place. Notable among them is Judaism, represented in the City by the Bevis Marks Synagogue, which has long been a focus for Anglo-Jewry. This has flourished in its present location for more than three centuries. The Muslim faith, in contrast, has no permanent space of its own, which means that Friday Prayers are held in hired rooms. One such location is the Wax Chandlers' livery hall. Every Friday the Muslim faithful stream in to fill staterooms on two floors. Sikhism also has no permanent built space but

Sikhs have found a location for weekday prayer in the Bedouin Tent at St Ethelburga's Centre for Reconciliation and Peace.

Given both the energy and the variety of the beliefs to be found within the contemporary City, it is not surprising to discover that it offers a stage to fascinating personalities. Some of these are people who straddle two worlds. Nick Mottershead, for example, is both the chief financial officer of a City company and a self-financing minister at St Olave Hart Street.

There is a constant interchange between religion – as represented particularly by the Anglican church – and other organisations associated with the City of London, among them both ancient and more modern livery companies and the legal Inns of Court. There are also links to business and the armed forces. These links and interchanges are sometimes commemorated by church ceremonies – for example, by the annual service in February at St Botolph without Aldgate that commemorates the birth of Sir John Cass and the contribution that the Cass Foundation continues to make to education. This is attended by the Lord Mayor and by lively schoolchildren, current beneficiaries of the Foundation.

Some livery companies maintain links with City churches. Every St Luke's Day since 1683, for example, the Worshipful Company of Painter-Stainers, led by its Beadle, Master and Wardens, has attended a festival service at St James Garlickhythe. At St Giles' Cripplegate, there is an annual Guild service for the Worshipful Company of Gardeners. Similar events are held by other groups. For example, newly qualified barristers attend a Call Day service of thanksgiving at Lincoln's Inn Chapel after their graduation. The Royal Marines hold an annual carol service at St Lawrence Jewry, with their regimental colours on display.

Other ceremonies with links to the church are more specialised. At the Knollys Rose Ceremony, which dates back to the fourteenth century, a freshly picked rose from the garden of All Hallows by the Tower is carried through the streets to Mansion House on an altar cushion by a verger of the church. It is escorted to its destination by members of the Worshipful Company of Watermen and Lightermen and is presented to the Lord Mayor as a penalty for building a bridge across Seething Lane in 1381.

More recent in origin is the Butterworth Charity service held at the church of St Bartholomew the Great. This originated in 1887 but continues a long tradition of giving money to the local poor.

Sometimes commemorative services are held for things that have nothing directly to do with the City of London. Every August a service is held at All Hallows by the Tower to commemorate the siege of Malta during the Second World War. A monument to the siege now exists close to the church, where wreaths are laid in memory of the civilian and military personnel who died. This is a reminder of the position held by the City at the heart of the whole British Commonwealth.

One sign of the equally central position held by the City and its buildings and institutions within the cultural history of Britain itself is through all types of music-making. Some of this is deeply traditional, and some is not. At St Mary Woolnoth, for example, you can hear individual singers with guitar accompaniments. At the church of St Katherine Cree on St James's Day there is a service with Lloyd's Choir. Afterwards a jazz band leads everyone out into the surrounding garden and plays during a festive supper.

These concerts offer a contrast to the choral music to be heard at the Romanian Orthodox services at St Dunstan-in-the-West. Here a male chanter is answered by a group using only five notes. The beautiful acoustic at St Margaret Pattens has inspired the cello teacher Mayda Narvey to hold her classes there.

Music in the City is not, however, confined to church settings. A Salvationist brass band plays at the Salvation Army's International Headquarters, for example, when the moment comes to welcome a new general. World music is heard at St Ethelburga's Centre for Reconciliation and Peace.

Not surprisingly, one of the main genres of music-making in a territory rich in so many historic churches is bell-ringing. Founded in 1637, The Ancient Society of College Youths is in charge of ringing the bells in the numerous City bell towers.

Meanwhile, the City's historic buildings – including its churches – pay their way to meet, amongst others, increasing heavy maintenance costs, by taking in paying guests. Often these guests are themselves charitable enterprises. The aptly named St Andrew by the Wardrobe has played host to Suited & Booted, a charity that helps young men by preparing them for job interviews. The help extends beyond providing suitable clothing. It also offers advice and training about what to expect at the interview itself and how to respond.

The annual City Prayer Breakfast, held at the Church of the Holy Sepulchre each October, has now passed its fiftieth anniversary. This is an annual event for Christians working in the City that focuses on the power of prayer.

Reaching out to members of the financial community, which is at the heart of the City of London, is seen as part of the duty of the Church. On Remembrance Sunday every year, Anglican clergy lead short services in City offices. Well-off financial staff are not the only people whom the Church aims to support. Since 2017, a trained group of volunteers called the City Pastors, led by Tony Thomas, Chaplain to the City of London Police, has patrolled the night-time streets, offering care to those who might need it. The care they provide ranges from the offer of a bottle of water to philosophical discussions.

Meanwhile, at the Centre for Church Multiplication, based at the City church of St Edward King and Martyr, a dynamic enterprise aims to resuscitate dormant parishes and create new ones throughout the whole of Britain.

In religious, as well as in purely financial terms, the ancient City of London is still very much what it has always been throughout its existence – a place where things begin.

Preconceptions

There is only St Paul's Cathedral, hosting very formal, ceremonial events. The City is essentially a 'godless' place dedicated exclusively to money-making.

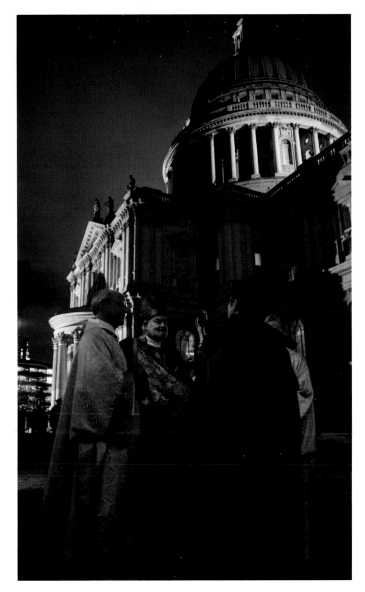

Rising to the occasion

[opposite] Celebrations for the outgoing Bishop of London, Richard Chartres, flow from St Paul's Cathedral, world-famous for such grand scale events.

Farewell to a Bishop

[above, left & right] High ceremonial send-off at St Paul's Cathedral for Richard Chartres, Bishop of London for twenty-two years.

Street credibility

Revealing a more relaxed side to his ministry, Bishop Richard chats to those who've come to wish him well outside St. Paul's Cathedral.

Two sides of a spiritual coin
Another bishop, this time Rob Wickham,
Bishop of Edmonton, hosts the farewell
'pop-up cathedral' events for Bishop
Richard in Paternoster Square, running
alongside the more formal ones inside
St. Paul's Cathedral.

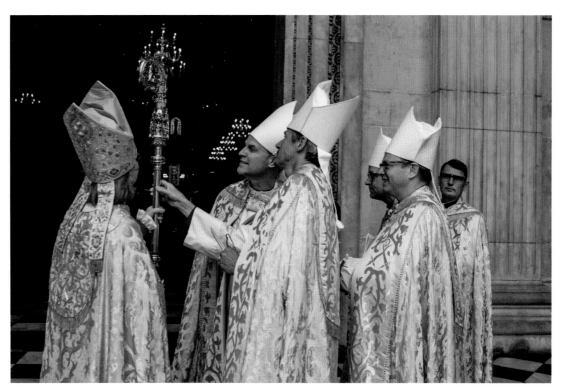

London blessing

[opposite] More grand ceremonial at St. Paul's Cathedral, as the new Bishop of London, Sarah Mullally, greets the capital after her official installation.

Checking out the crosier

[above] Bishop Sarah's staff creates much curiosity from her fellow bishops in the wind down after all the ceremony.

Is the City of London a 'godless' place?

[above] The crowds outside St Paul's Cathedral for Bishop Sarah's blessing on Palm Sunday.

Making a splash

[opposite] Bishop Sarah brings a sense of fun to Palm Sunday on the steps of St Paul's Cathedral with liberal sprinklings of holy water.

The unexpected

There is a strong spiritual life, not just in St Paul's Cathedral, going back in history to the Romans. Contrasts and surprises of all kinds in over forty different places of worship within The Square Mile.

The spiritual life within

[opposite] Push open the doors of most City churches and you will usually find something going on. Here at St Magnus the Martyr, it is High Mass before the Annual Blessing of the River Thames.

Full house

[above] Some City churches, such as All Hallows by the Tower, are still parish churches, with regular services and a loyal following.

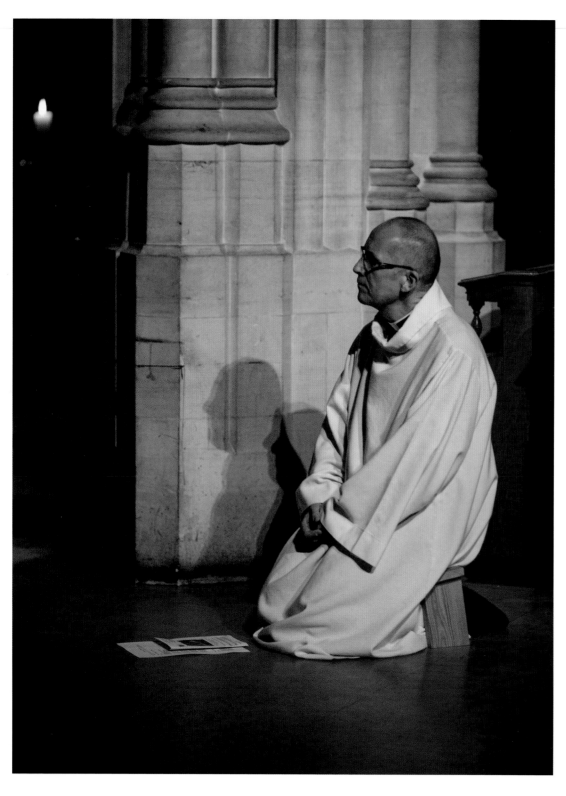

Sanctuary
Weekly Taize services offer a haven
of peace, calm and contemplation at
All Hallows by the Tower, led by its then
vicar Revd. Bertrand Olivier.

Livery wedding
Ushers from The Worshipful Company of Watermen and Lightermen pose with Revd. Bertrand Olivier and the groom's mother after a colourful marriage service at All Hallows by the Tower.

Harvest of the Sea
Billingsgate fish merchants raise money
for charity from their magnificent display
at St Mary-at-Hill's harvest festival service.

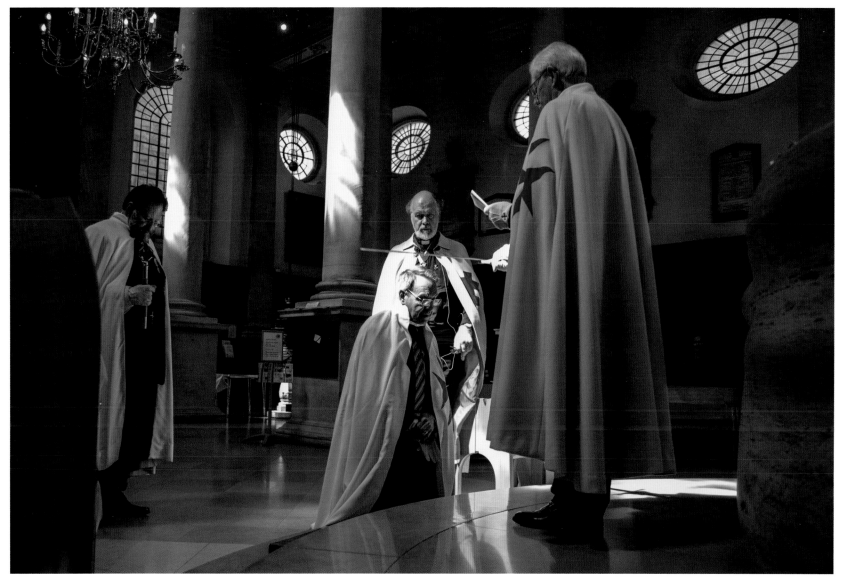

By the sword
Service of Investiture by The
Grand Priory of Knights Templar
at St Stephen Walbrook.

Secret sect

[left and above] Seven metres below its new European headquarters, Bloomberg has reconstructed the remains of The Temple of Mithras; an immersive experience of pagan worship in Roman London for almost 2,000 years.

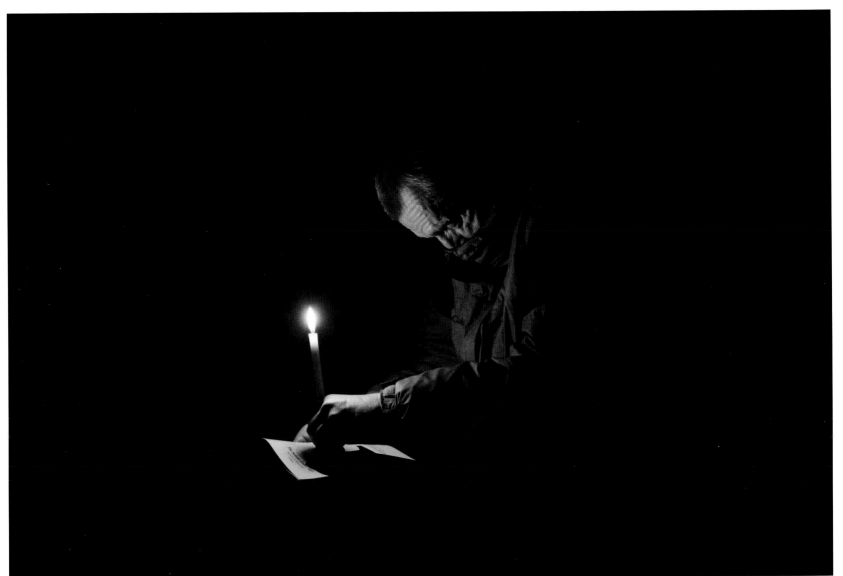

Pagan roots
Services within such ancient City churches as St Bartholomew the Great can still evoke the pagan rites from which much of faith today originates.

Palm Sunday parade

[opposite] A little help from holy water outside St Vedast-alias-Foster, as the procession makes its way through the streets of the City from St Giles' Cripplegate to St Paul's Cathedral.

The Way of the Cross

[above] To mark Good Friday, a large procession from St Mary Moorfields makes a complete circuit of The Square Mile, stopping at various points for prayer.

Solemn commemoration

Elsewhere on Good Friday, ministers show reverence before the high altar at St Bartholomew the Great's Liturgy of the Passion service.

Easter emotion

[right and below] The deep sorrow and light-bringing joy of this important Christian festival are still dramatically expressed within City churches.

Feeding more than the soul

Host Cafe within St Mary Aldermary sells
excellent coffee and food, even while
services are in progress. Highly popular,
it gets City workers through the door
and informally opens up opportunities
to explore spirituality.

Partying amongst the pews

Social interaction after services is
common in the City churches; all part of
the natural urge to network within The
Square Mile's busy financial community.

Art opening
[left] Marine Lewis with her 'Colourblind' exhibition of portraits in St Mary-at-Hill.

Christian classroom
[left] Although still very much a sacred space, St Edmund King and Martyr is now the Centre for Church Multiplication and is often filled with teaching sessions.

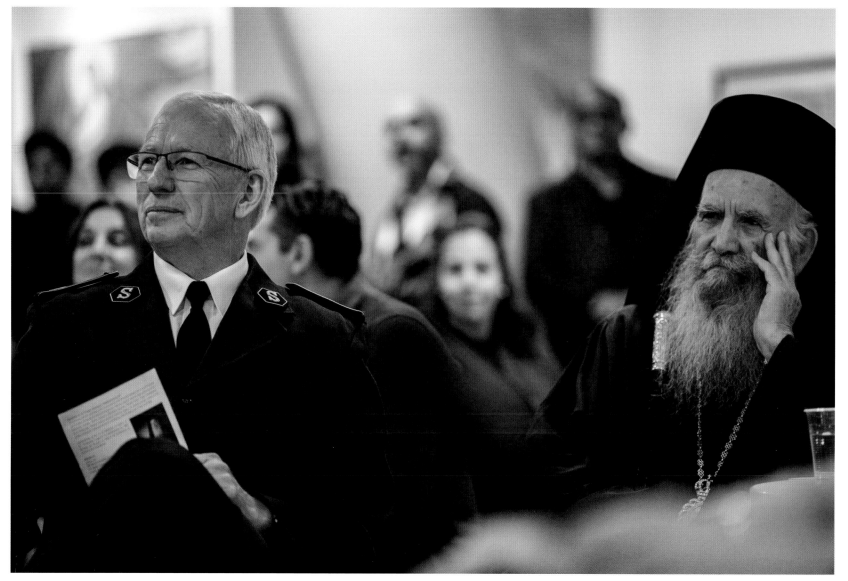

Surprise pairing
The Salvation Army's General Brian
Peddle with His Eminence Archbishop
Gregorios of Thyateira and Great Britain
during an art show in the latter's honour
at the Salvation Army's International
Headquarters, close to St Paul's.

Parish notes

Regular worship is still happening in City churches, from daily communions and weddings to festival services and prayer meetings.

Sunday service

[opposite and right] There is an emphasis on the family at St Botolph without Aldgate's regular Sunday Eucharist with Revd. Laura Jorgensen.

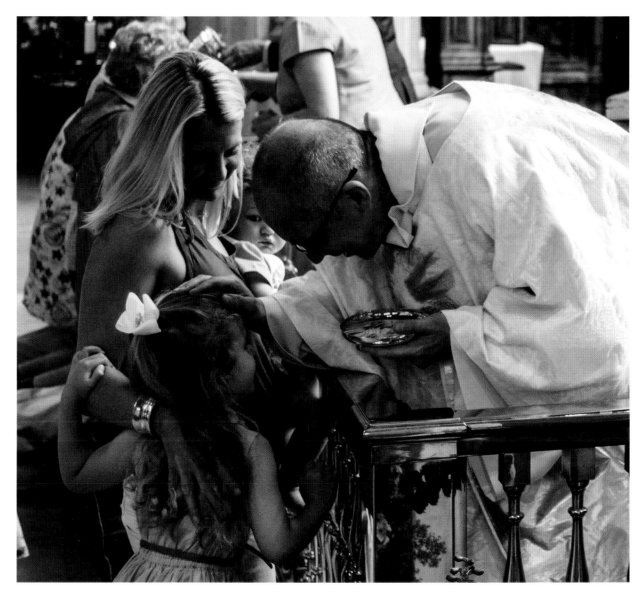

Friday Mass

[opposite left] Father Chris Vipers prepares the Eucharist at the high altar in St Mary Moorfields, the only Roman Catholic church within The Square Mile.

Communion from above

[opposite right] The Venerable Luke Miller, Archdeacon of London, dispenses the consecrated bread and wine at St. Andrew by the Wardrobe.

Bless the children

[above] Sunday services at All Hallows by the Tower also attract young parishioners.

Married in style

The beauty of City churches, together with their characterful vicars, makes them popular as wedding venues. Here the Revd. Prebendary Jeremy Crossley gives both heart-felt and entertaining marital advice in St Margaret Lothbury.

Palm Sunday traditions

[right and below] Revd. Katharine Rumens oversees the careful combining of a trumpet fanfare with live animals at St. Giles' Cripplegate, the parish church within the City's Barbican Estate. Every year, on this first day of Holy Week, donkeys are welcomed as an integral part of the service, both inside and out.

Contemplating the labyrinth

On the Wednesday of Holy Week, Revd.
Katharine Rumens leads a workshop to
reflect on the labyrinth laid out in the nave
for prayer and meditation.

From light to dark

[right] Walking the labyrinth
before the Tenebrae Service at
St. Giles' Cripplegate.

Maundy Thursday

[right] During the meal in the nave of
St. Giles' Cripplegate to commemorate
The Last Supper, Revd. Katharine
Rumens washes the hands and feet
of her parishioners.

The light returns

[this spread] The first fire of Easter is lit in St Bartholomew the Great's cloister before the Paschal Candle is carried through for the First Mass.

Easter vigil
St. Giles' Cripplegate stays open for silent prayer until midnight on the Thursday before Easter, in total darkness except for the candles lit by parishioners as they gradually leave.

Circle of light

[right] Revd. Bertjan van de Lagemaat leads a family-focused Resurrection Service on Easter morning at the Dutch Church in Austin Friars, founded by protestant refugees from the Netherlands in 1550.

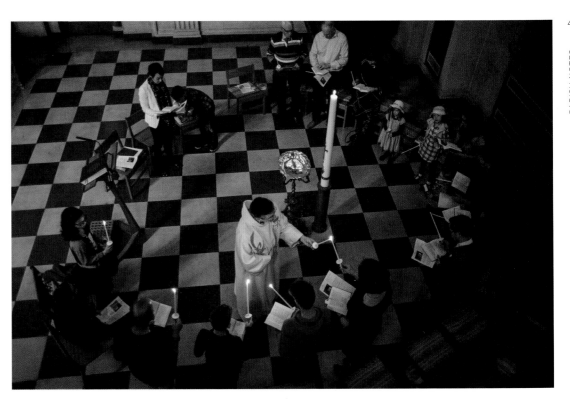

Dawn Service

[right] Easter morning worship starts at 6am at St Bride's Church, with a service of light and celebration of the resurrection.

Egg rolling anyone?

[this spread] By 7.15am, the whole congregation at St Bride's is outside ready for another great Easter tradition of egg rolling down Fleet Street, with the Revd. Canon Dr. Alison Joyce leading the competition to roll the furthest, buses and taxis permitting.

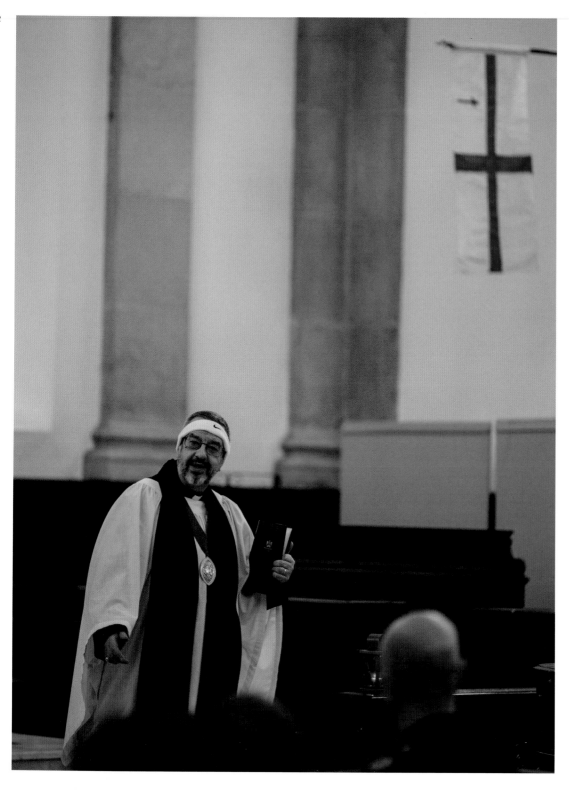

Renowned for his witty sermons, Revd. Canon David Parrott dons a sweat-band at St Lawrence Jewry next Guildhall for one his many Christmas carol services.

Christmastide

St. Lawrence Jewry's status as the official church of the Lord Mayor of London and the City of London Corporation, as well as its many links with Livery Companies and Britain's military forces, means that it is often hosting three carol services a day in the run up to Christmas.

Depth and breadth

There is a great diversity of religious events and services within the City, encompassing many faiths and ways of worship.

High Mass

[opposite] Worship at St Magnus the Martyr is within the Anglo Catholic tradition, led by the Cardinal Rector Revd. Father Philip Warner.

Finding Salvation

[right and below] In the Salvation Army's ultra-modern International Headquarters, staff hold morning prayers in a chapel filled with light reflected in through a 'sky wall' of glass panels.

One altar, two congregations

[this spread] As Rector of St Andrew by the Wardrobe, Father Luke Miller leads a weekday Mass every month. Every Sunday, Father Jacob Anish Varghese leads a Eucharist service for the St Gregorios Indian Orthodox Church.

Church revitalised

[this spread] Over forty years ago, the newly-arrived Indian Orthodox community were looking for somewhere in central London to worship. Closed on a Sunday, the underused St Andrew by the Wardrobe offered the perfect solution and they have been holding their three-hour long, family services here ever since.

City Catholics

[left and below] Once illegal and secretly practised in small chapels, Roman Catholic worship now thrives at St Mary Moorfields, catering to mainly non-resident City workers who often attend daily.

Missa Solemnis

A Solemn High Mass is celebrated in full ceremonial form at St Mary Moorfields.

Cathedral Synagogue

[above and left] Bevis Marks is the only synagogue in Europe that has held regular services for over 300 years and continues to host major ceremonial services for Anglo-Jewry, as well as family celebrations. Here, Rabbi Morris leads a blessing before the Ark and Torah scrolls during a wedding.

Open to all comers

[above and right] City Temple is the only English Free Church in the City of London worshipping in its own building every Sunday, with music and dance all part of its evangelical openness.

Romanian Orthodoxy

St. Dunstan-in-the-West has been
the spiritual home of the Romanian
community in London for over 50 years,
with Sunday services attended by up
to 400 people.

Family focus

[this spread] Led by Father Constantin
Popescu, the full morning Sunday service
is both formal and relaxed, with whole
families attending and worship centred on
the distinctive Catapeteasma, the richly
carved altar carefully transferred from
a Romanian monastery and installed
at St Dunstan-in-the-West in 1966.

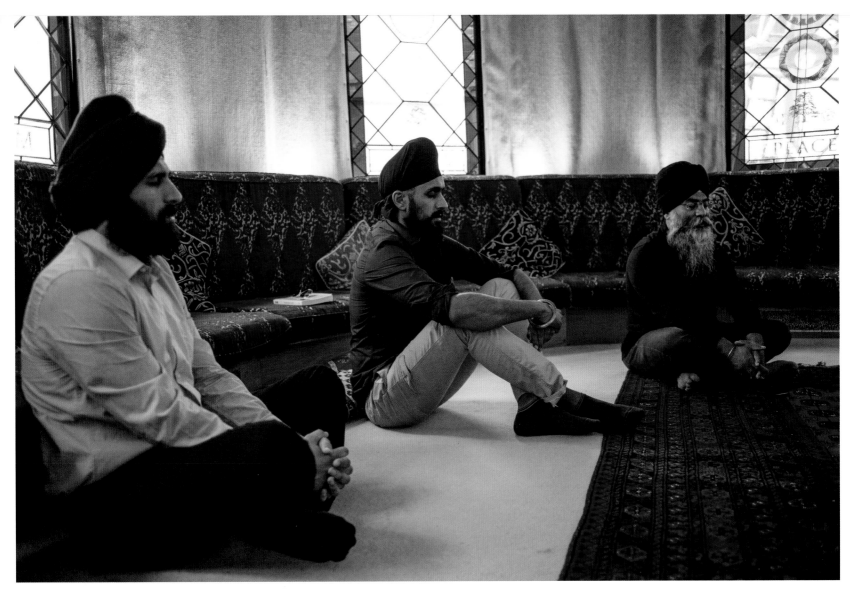

Tented prayer

[this spread] There is no gurdwara temple in the The Square Mile but the Sikh business community have found the space they need for weekday prayer within the unique calm of the Bedouin Tent at St Ethelburga's Centre for Reconciliation and Peace.

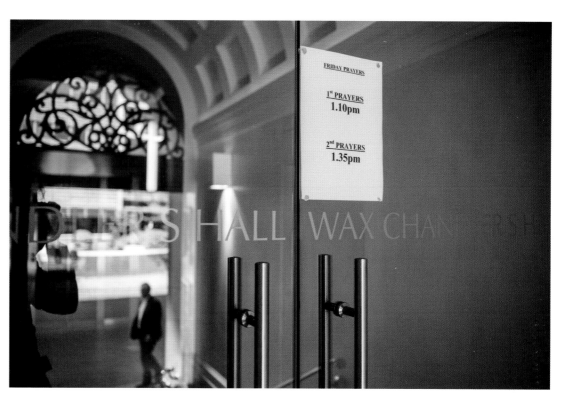

Called to prayer

[this spread] No mosque within the City means that Muslim Friday Prayers are held in hired rooms, such as in the Worshipful Company of Wax Chandlers' livery hall. Workers from nearby offices stream in to fill two floors of these grand staterooms near Guildhall.

Symbol of Welsh culture

[left] As the oldest Welsh Church in London, the Jewin Chapel follows the Presbyterian tradition of simplicity in their services. There is a strong focus on the preacher, often visiting from other Welsh churches, as with the Revd. Gerallt Lloyd Evans, all the way from Anglesey for St. David's Day.

Welsh Anglicanism

[left] Revd. Dr. Aneirin Glyn leads the Sunday service at St Benet's, Paul's Wharf, speaking in both Welsh and English. Welsh Anglicans persuaded Queen Victoria to allow them to worship here in 1879 and since 1954, it has held weekly services as The Metropolitan Welsh Church.

Simple spirituality

[right] Founded in France in the 1940s by a monastic community, Taize prayer services of short, repeated Latin chants to encourage meditation have grown in popularity in both Catholic and Protestant churches, particularly with younger people. At All Hallows by the Tower, a brother from the French Taize Community leads a service of Lenten Prayer around the Cross.

Hi-tech worship

[right] Revd. Nick Mottershead utilises the convenience of modern technology to lead a half-hour lunchtime service of music and prayer at St Katharine Cree.

Characters

The City of London fields an impressive array of energetic, imaginative and popular clergy.

Interfaith dialogue

[opposite] The first woman Anglican Bishop of London, Sarah Mullally, chats with His Eminence Archbishop Angaelos, Coptic Orthodox Archbishop of London, at her St Paul's Cathedral installation service in May 2018.

Subversion for Christ

[right] As an ex-nurse, Bishop Sarah brings a down-to-earth determination to reimagine the Church of England's shape and ministry in London. For her, the church does not have the luxury of remaining unchanged and she emphasises building relationships and making the church more reflective and relevant to the surrounding community.

Picture this

The Venerable Luke Miller, Archdeacon of London, is an avid tweeter and social media enthusiast, always keen to raise the Church of England's online profile. Here he snaps the audience at the 'pop-up cathedral' in Paternoster Square for Bishop Chartres' farewell celebrations.

Behind the scenes

[right] Clerical camaraderie in the vestry after a service at St Katharine Cree.

Multi-tasking

[right] At one time The Revd. Prebendary Rose Hudson-Wilkin juggled the demands of being Priest-in-Charge at St Mary-at-Hill, as well being Chaplain to the Queen and Chaplain to the Speaker of the House of Commons. Now she has moved on to become Bishop of Dover.

Celebratory Cut

[opposite] The highly popular Revd. Bertrand Olivier celebrates his 10 year anniversary as vicar of All Hallows by the Tower. He is now Dean and Rector of Montreal's Christ Church Anglican Cathedral.

Baton passed on to …

[above] Revd. Katherine Hedderly at All Hallows by the Tower. Also Area Dean to The City of London, her background as a producer and director in the pressurised world of film and television, gives her a diplomatic head start in balancing the great diversity of traditions amongst the City Churches.

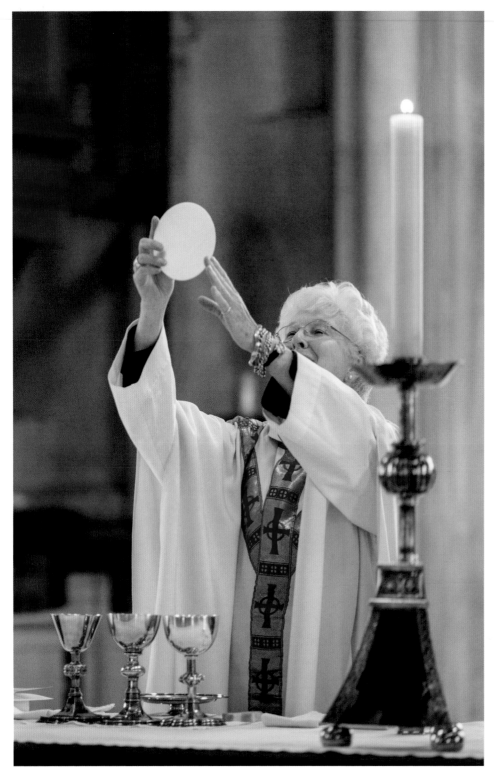

Artistic match

As an ex-art teacher and fashion designer, Revd. Katharine Rumens was an ideal choice in 2000 to become Rector of St. Giles' Cripplegate, the parish church for the Barbican Estate and Arts Centre. She is now one of the longest serving and most popular vicars within the City, with a loyal following amongst the Estate's residents.

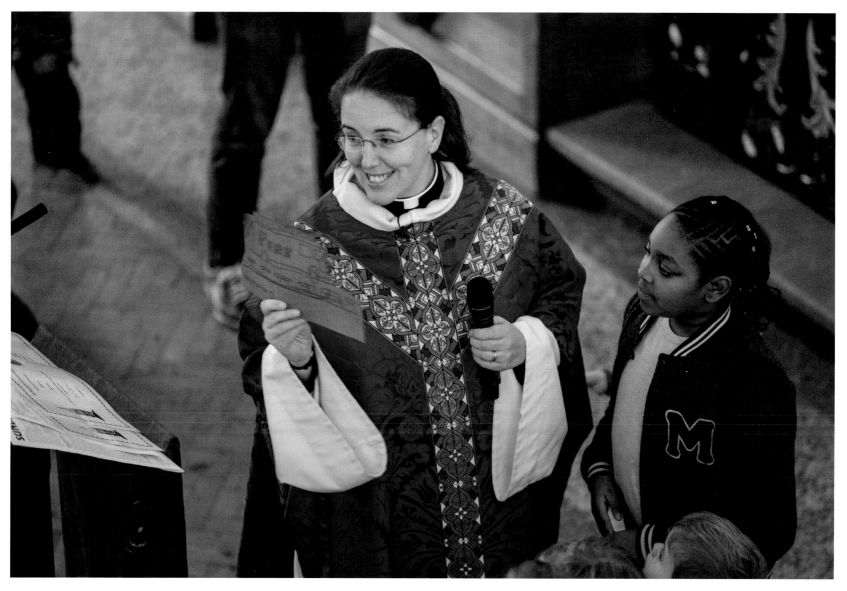

Mother's ministry

Revd. Laura Jorgensen has been Rector at St Botolph without Aldgate since 2009 and has fostered a family-friendly ethos within her church, not least by giving birth herself. As the then Bishop of London, Richard Chartres, put it at her son's christening: "For the first time in over nine centuries, the Rector has had a baby!"

Top brass changeover

[this spread] The new General for the Salvation Army, Brian Peddle, and his wife Commissioner Rosalie (on left) are welcomed to the International Headquarters near St Paul's Cathedral by the leaders of the UK and Republic of Ireland Commissioners, Lyndon and Bronwyn Buckingham. As the 21st General, Brian is the spiritual leader of one million Salvationists and oversees more than 100,000 employees across 127 countries.

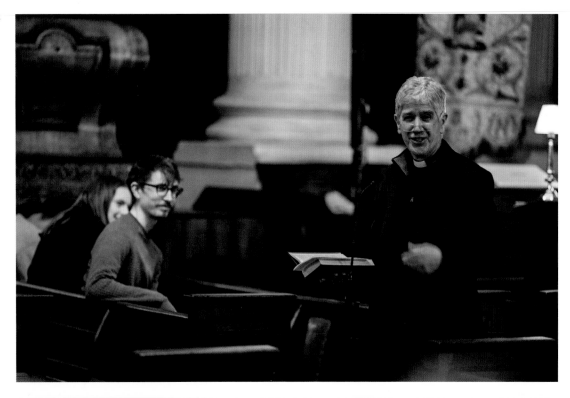

Putting heart into the City

[left] As Rector of three churches around Bank Junction, The Revd. Prebendary Jeremy Crossley has created an inviting lunchtime mix of traditional, structured services and informal, 'come and go as you please' prayer meetings, all characterised by warmth and humour.

Straddling two worlds

[left] Revd. Nick Mottershead manages to balance life both as a City company's chief financial officer and as a self-financing minister at St Olave Hart Street.

Lutheran connections

[right] Revd. Eliza Zikmane is Pastor in Charge of St Anne's Lutheran Church, which uses the Anglican Church of St. Mary-at-Hill for its Sunday services and Bach Vespers musical evenings. Lutherans have worshipped in England since the 17th century, with over 100,000 now in Britain, mainly from Nordic countries.

Dutch relations

[right] In the 16th century, King Edward VI gave persecuted refugees a church building in Austin Friars to worship in freely as reformed Calvinists. Revd. Bertjan van de Lagemaat continues this tradition at the same location over 400 years later, where weekly Sunday services and events are still a focus for Britain's Dutch community.

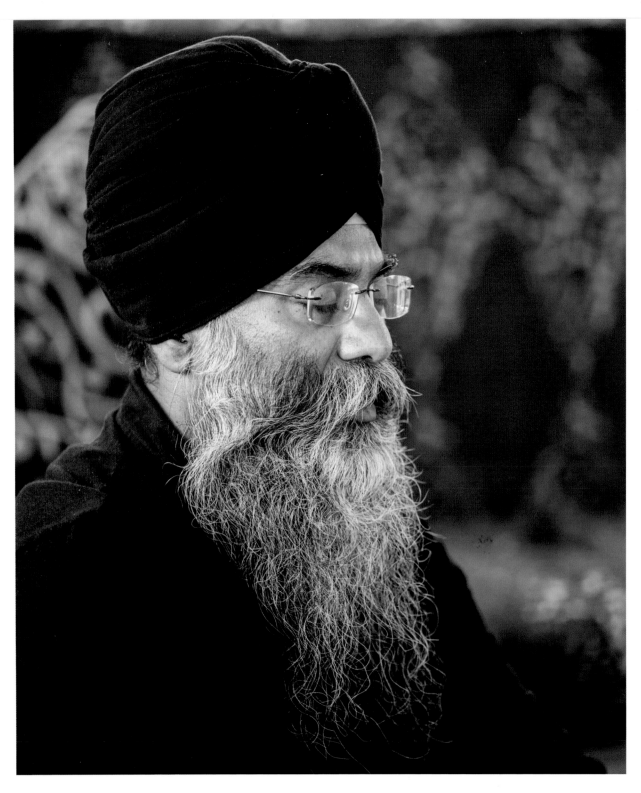

Spiritual space
Mandip Singh leads weekday lunch-hour prayer and discussion sessions for Sikh City workers inside the Bedouin Tent at St Ethelburga's Centre for Reconciliation and Peace.

Catholic inspiration
Father Chris Vipers has been the enthusiastic parish priest at St Mary Moorfields since 2016, handling a busy weekday schedule of well-attended twice-daily Masses and Confessions, as well as leading Mass on Sundays and heading up Young City Catholics, a flourishing networking group for City workers in their 20s and 30s.

Father figure

[left] Since 2013, Father Constantin Popescu has been parish priest for the large Romanian community in London worshipping in the Romanian Orthodox Parish of Saint George the Great Martyr at St Dunstan-in-the-West. Hundreds fill the church every Sunday to hear his sermons.

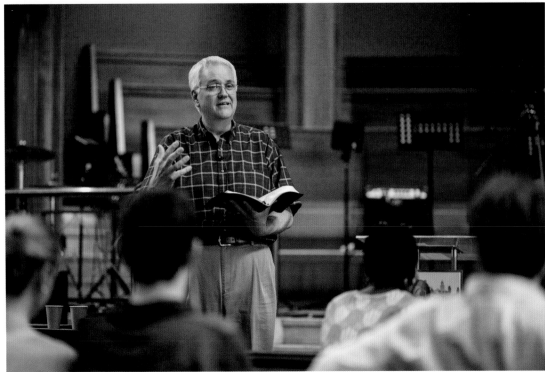

International focus

[left] For over 18 years, Revd. Dr. Rod Wood has been bringing an American warmth and energy to his evangelical ministry at City Temple.

Keeper of the thurible

[right] Supporting servers play a vital role in all City churches. The thurifer's job at St Magnus the Martyr is to prime the censer and then swing it through the air to release incense smoke as a symbol of prayers rising to heaven.

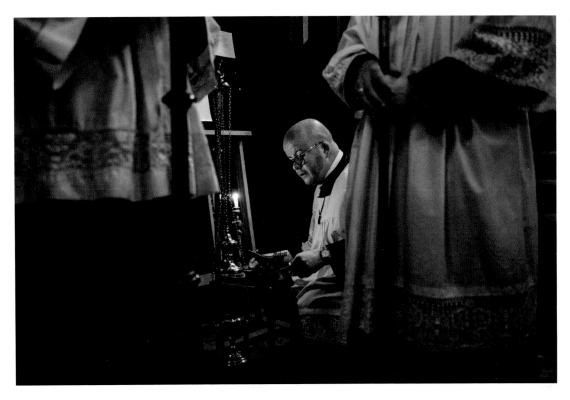

Clerical chat

[right] After-service socialising at St Stephen Walbrook with its then vicar, Revd. Jonathan Evens and the Master of Temple Church, Revd. Robin Griffith-Jones.

Outside relations

City churches have unique links with the City of London Corporation, The Square Miles' 110 ancient and modern livery companies, the legal Inns of Court, the armed forces and business. Nowhere else will you find such intriguing crossovers.

Civil partnership

[opposite] An ornate sword rest in St. Giles' Cripplegate features the coats-of-arms of five parish aldermen who have become Lord Mayors of London, highlighting the close ties between church and City.

Marking the Mayoralty

[above] As the parish church for Mansion House, the Lord Mayor's residence next door, St Stephen Walbrook hosts the annual Service of Thanksgiving for the public service of each Lord Mayor. It's an opportunity for the incumbent to come and give thanks for the achievements possible from holding this high office. On this occasion it was Alderman The Lord Jeffrey Mountevans.

Founder's Day

[left] Every February, a red-robed Lord Mayor takes the front pew in St Botolph without Aldgate to help commemorate the birth of Sir John Cass in 1661 and celebrate the continuing contribution his Foundation makes to education in and around the City of London. The Venerable Luke Miller, Archdeacon of London, is in full flow with an entertaining sermon for the schoolchildren attending.

High Sheriffs

[left] As ambassadors for the City of London, Dr. Christine Rigden and Alderman Charles Bowman socialise after a service at St Stephen Walbrook in their full formal robes. The ancient role of City Sheriff dates from the 9th Century. Elected for a one-year term by the livery companies, their duties require them to support the Lord Mayor, entertain Her Majesty's judges at lunch each day and live at the Old Bailey.

City ceremonial

[right] Formal entrances and exits are not just for the clergy. As one of the original Great Twelve Livery Companies founded in the Middle Ages, the Beadle, Master and Wardens of The Drapers' Company process into St Michaels' Cornhill for the annual City New Year Service. Also usually attended by the Lord Mayor and the Governor of the Bank of England, this service comes with a follow-on invitation to enjoy a gratis buffet lunch at the Drapers' Hall close by.

Building on tradition

[right] Revd. Canon David Parrott at St Lawrence Jewry leads the Installation Service of the new Master of The Worshipful Company of Constructors, a modern livery company of professionals working in the construction industry that only received its royal charter from the Queen in 2010.

Livery links

[this spread] The Worshipful Company of Painter-Stainers is one of three City livery companies that continues the ancient custom of processing to church on its patron saint's day in full gowns and hats and carrying posies. On every St Luke's Day since 1683, they have attended St James Garlickhythe for a Festival Service, led by its Beadle, Master and Wardens.

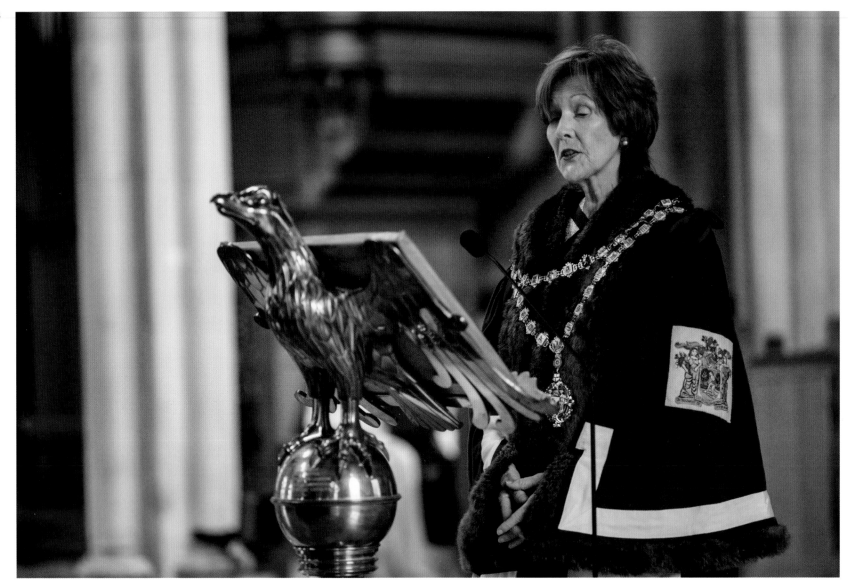

Gardeners' world

Unlike many livery companies, The Worshipful Company of Gardeners is a 'living' guild, with both professional and amateur members actively involved in the craft of horticulture. At St Giles' Cripplegate, the then Master Margie Holland Prior reads the lesson at their annual Guild Service.

Outgoing chaplaincy

[right and below] Livery companies traditionally appoint a chaplain from the City's clergy to minister to their members' spiritual needs. For The Worshipful Company of Water Conservators, Revd. Rose Hudson-Wilkin brings both support and humour to the role at a livery meeting in Trinity House.

Called to the Bar

The Venerable Sheila Watson, Preacher at
Lincoln's Inn Chapel, rehearses readings
with newly-qualified barristers before
a Call Day service of thanksgiving after
their graduation.

Ministering to the military

All branches of Britain's armed forces
maintain close links with the City churches.

Lest we forget

[this spread] Remembrance Day is a particularly affecting day in City churches. At St Katharine Cree, The Lloyd's (Insurance) Branch of the Royal British Legion brings together young and old in a Service of Remembrance.

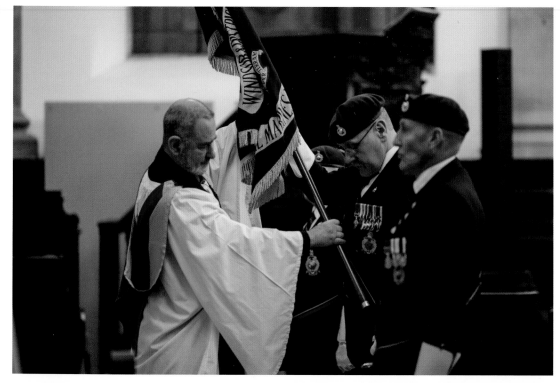

Green berets at Christmas

[left and below] The Royal Marines always hold their annual carol service at St Lawrence Jewry, their traditional Colours and renowned buglers creating a unique atmosphere.

Commercial connections

The City churches' priority is to minister effectively to the needs of the business community surrounding them. Here Revd. Sally Muggeridge hosts an evening celebrating the contribution of women to City business with guest speaker, Glen Moreno.

Unique history celebrated

Anniversaries and traditions from the City's complex past are still honoured by the City churches, creating a surprising mix of annual and one-off events.

Beating the Bounds

[this spread] Continuing a tradition from medieval times, All Hallows by the Tower determinedly reaffirms its parish boundaries every year with a procession of City and Livery representatives and the help of students from the once-local St Dunstan's College. The southern boundary lies mid-stream in the River Thames, requiring some creative waterborne marking.

Blessing the Thames

[this spread] Revd. Father Philip Warner leads a parish procession from St Magnus the Martyr to meet the clergy and congregation from Southwark Cathedral in the middle of London Bridge. Prayers are said for all those who use the bridge or ply the river, before a wooden cross is thrown into the waters below, combining the Eastern Christian tradition of blessing water with the celebration of Christ's baptism by John the Baptist.

For the price of a rose

[this spread] Dating back to the 14th century, The Knollys Rose Ceremony requires a freshly-picked red rose from the garden of All Hallows by the Tower to be carried through the City's streets by the verger on an altar cushion, all the way to Mansion House, with an escort from The Worshipful Company of Watermen and Lightermen. The livery company's Master then presents the rose to the Lord Mayor as an annual penalty for building a footbridge across Seething Lane in 1381, as imposed by The City on Sir Robert Knollys and his 'heirs and assigns, for ever'. On this occasion, it was presented to The Right Honourable The Lord Mayor Alderman Charles Bowman.

Good Friday charity

[left and below] A 'widow of the parish' claims her coin from Revd. Marcus Walker as part of the Butterworth Charity service at St Bartholomew the Great, continuing this tradition of giving money to the local poor since 1887. Those attending can enjoy the free hot cross buns afterwards.

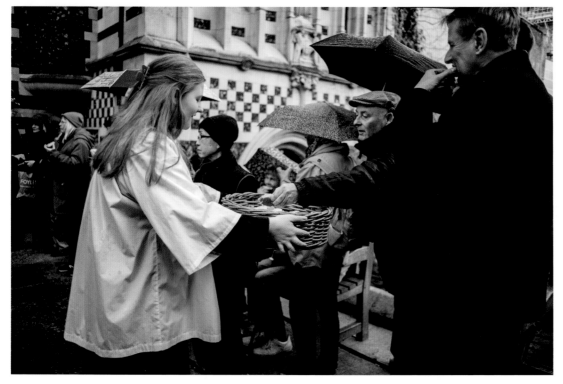

Destruction and rebirth

[right and below] For the 350th Anniversary of the Great Fire of London, clergy from many City churches came together to process through the City streets from St Mary-at-Hill to St Magnus the Martyr. Along the way, they stopped at Pudding Lane, where the fire started, for prayers and a reading by The Revd. Prebendary Rose Hudson-Wilkin and at the commemorative Monument itself for further thanksgiving by The Very Revd. Dr. David Ison, Dean of St Paul's Cathedral.

Malta remembered

[this page and following spread] Every August, Colours are laid on the altar at All Hallows by the Tower during a service to commemorate the World War II Siege of Malta. The island was collectively awarded the George Cross and a memorial was built close to the church in 2005, where wreaths are laid for the 7,000 civilian and military lives lost.

Let there be music

There is an incredibly high standard of singing and music of all types within the City churches.

Heavenly heights

[opposite] The Temple Church Choir is the epitome of a top-class choral group. Its eighteen boy-choristers and twelve choirmen are renowned for producing sublime singing within the magnificent acoustics of the church, as well as for tackling new works and touring the world.

Making connections

[right and below] Schools welcome the many invitations to showcase their musical skills in City churches. St. Dunstan's College Chapel Choir are put through their paces during a Harvest Festival service at All Hallows by the Tower, whilst children from the Sir John Cass Schools prepare to play during a Foundation Day service at St Botolph without Aldgate.

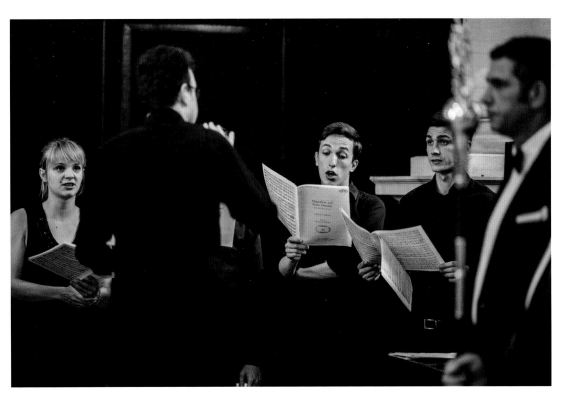

Choral abundance

[this spread] City workers who still love to sing bring a wealth of experience and expertise to a remarkable range of church choirs, large and small. As one of London's leading vocal ensembles, the 30-strong English Chamber Choir rehearses and performs at St Andrew by the Wardrobe, whilst the smaller choir of The St Stephen Voices brings impressive musical uplift at St Stephen Walbrook.

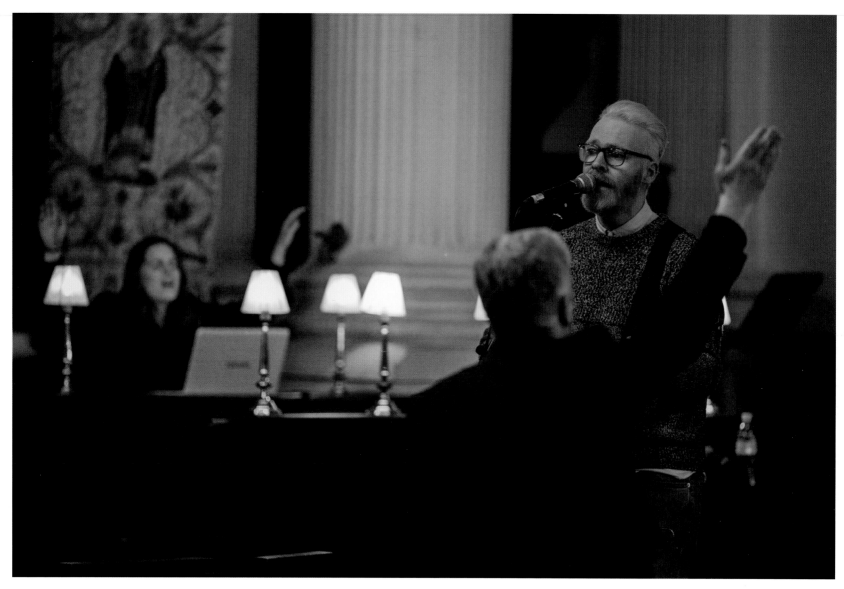

Lifting hands and voices

Less traditional lunchtime services at
St. Mary Woolnoth create an inspirational
atmosphere with individual singing and
a guitar accompaniment.

Evangelical approach
Music at Holy Sepulchre favours
contemporary instruments and digital
presentation to encourage active
participation and a communal experience.

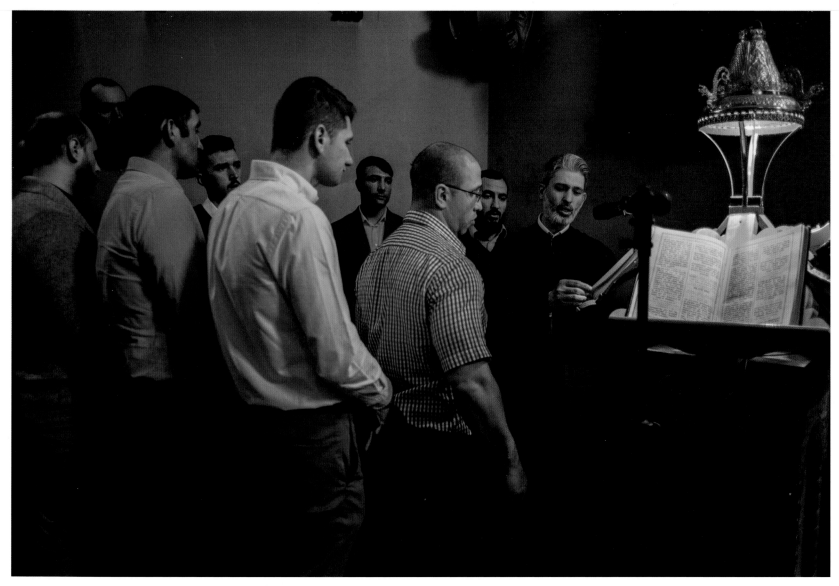

Romanian chants

No instruments are used in Orthodox
Romanian services, just the male voice.
A main chanter is answered by a larger
group using only a few notes in steady,
rhythmical chanting to create a beautifully
calming sound, conducive to an elevated
state of mind.

Organ masterclass

St. Lawrence Jewry can boast one
of the most experienced organists
in the country as its Director of Music.
A former President of The Royal College
of Organists, Catherine Ennis is much
sought after as an enthusiastic teacher
of the instrument.

Cello inspiration

Mayda Narvey finds that the beautiful
acoustics of St Margaret Pattens makes it
an ideal place to teach her students.

Palm Sunday fanfare
A brass and drum flourish from behind
the altar at St Giles' Cripplegate adds
a triumphant dimension to this service
marking the beginning of Christian
Holy Week.

Oh when the saints, go marching in

A jazz band leads the the Lloyd's Choir
and congregation into the garden for a
celebration supper after the St James Day
service at St Katharine Cree.

Playing for The General

[left] For non-Salvationists, brass bands are the most recognisable feature of the Salvation Army. The welcome ceremony for the new General at International Headquarters features a prime example of this tradition of exuberant musicianship.

World music

[left] StEthelburga's Centre for Reconciliation and Peace hosts an evening of Afghan music by Veronica Doubleday and John Baily, with some impromptu dance.

Classical master

St. Stephen Walbrook offers the
internationally acclaimed Claudio
Crismani the perfect setting for one
of many concerts performed beneath
its famous dome.

Barbican Sounds

[this spread] Embracing its role as the Barbican Arts Centre's parish church, St Giles' Cripplegate opens its doors to become a venue for the 'Sound Unbound' Festival. To large audiences over a May weekend, it becomes a stage for the contrasting musical styles of the '12 ensemble' playing Mendelssohn and the Belgian electronic band 'Zwerm' performing their interpretation of Tudor music.

City bells

Founded in 1637, The Ancient Society of College Youths is still 'change ringing' with both energy and skill in City bell towers. At St James Garlickhythe, the eight Royal Jubilee Bells were only cast and installed in 2012, after memorably being rung on a barge at the head of the Queen's Diamond Jubilee celebrations on the Thames.

Ringing out

The 'Bow Bells' at St Mary-le-Bow are world famous and integral to the City's folklore, from confirming a true cockney to the well-known Lord Mayor Dick Whittington. With twelve bells in total, method ringing here is a real test of memory and concentration and The Ancient Society of College Youths holds regular practices.

Venues for hire

The City's ancient churches need continual upkeep, a cost not covered by either central funding or service collections. Creative fundraising is a necessary evil but paying guests also bring the benefits of new connections.

Singing supreme

[opposite] Bo Wang and the popular London Chinese Philharmonic Choir choose to regularly rehearse at St Mary Abchurch, due to its excellent acoustics.

A Russian Christmas

[right] No longer a parish church with regular services, St Mary Abchurch is now used by other visiting worshippers. Revd. Andrei Petrine is a Church of England minister with a parish in Essex but here leads a Christmas service as part of The Chaplaincy to Russian-Speakers in the Diocese of London.

Dickensian drama

[right] St Mary Abchurch becomes an evocative candlelit stage for actor, Martin Prest, performing 'A Christmas Carol' in one hour, just as Charles Dickens would have done, playing all twenty characters himself.

Pure in body and spirit

[this spread] Amanda Corsi takes City workers through their moves at her weekly Yoga class within the beauty and calm of St Anne and St Agnes. The church is designated a Chapel of Ease to St Vedast-alias-Foster nearby, with a few services held each year but the church is now run and maintained by VOCES8 Foundation, a music and education charity.

History brought to life

[this spread] The crypt at All Hallows by the Tower allows an actor to dramatically conjure up life in Roman Britain for a class of schoolchildren. Clio's Company specialises in interactive drama projects for schools, cleverly structuring history days in the church involving costumed action and then workshops in which children resolve historical questions for themselves.

Speaking out

[right] From in front of the altar at St Lawrence Jewry, Sharon Ament, Director of the Museum of London, delivers the annual Melluish Lecture for the City of London Guides, remembering the Great Fire of London on its 350th anniversary. Many such talks are scheduled every year at this busy church by Guildhall, usefully adding to the church coffers.

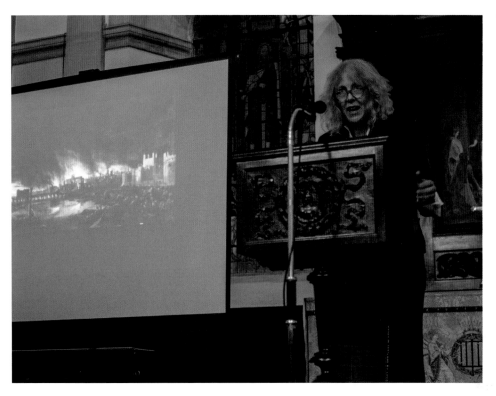

All part of the service

[opposite and right] St Lawrence Jewry have the post-event food and drink down to a fine art – even to the Revd. Canon David Parrott and Verger Arnel Sullano on washing-up duty.

Looking the part

[this spread] For a time, the perfectly-named St Andrew by the Wardrobe was home to the amazing Suited & Booted. As a charity transforming young men's lives by preparing them for interviews, its volunteers take those referred to them by public agencies and help kit them out in a good suit and all the right accessories. Advice, interview training and support follow, with a high success rate.

Friends in high places

[this spread] As Priest-in-Charge of a City church in need of funds, The Revd. Prebendary Rose Hudson-Wilkin saw a chance to capitalise on one of her other roles as Chaplain to the Speaker of the House of Commons by setting up a grand fundraising dinner at the Palace of Westminster, complete with an extensive raffle and Sir Trevor McDonald as the main speechmaker. It was a highly successful evening and St Mary-at-Hill's fire-damaged altarpiece was a big step closer to being restored.

Reaching Out

City clergy know very well that they need to connect with the financial community around them to thrive, not an easy task in the fast-moving, work-focused world of The Square Mile.

Spreading the word

[opposite] Despite excellent sermons within the beauty of All Hallows by the Tower from those such as the visiting Rt. Revd. Pete Broadbent, preaching from the pulpit and waiting for people to flock through City church doors are no longer reliable options. Outreach is seen as vital.

Meet and greet

[above] Setting the tone from the top, Sarah Mullally, gets out amongst the crowd immediately after her official installation ceremony at St Paul's Cathedral as Bishop of London.

Crossing the divide

[left and below] Revd. Nick Mottershead and Revd. Oliver Ross are out and about on Remembrance Day to lead short services within offices. It's an important opportunity to bring the practice of faith right into the centres of commerce.

Change of venue

To open up the possibilities for greater community involvement, St Olave Hart Street's weekly 'God at Work' sessions decamp to The Ship pub next door. Led by Revd. Nick Mottershead, these relaxed meetings aim to tackle the very relevant City issues around balancing work and faith.

Practical faith

[this spread] The City Pastors have
been putting the Samaritan spirit
into action on the late-night streets
of The Square Mile since 2017. Led
by Tony Thomas, Chaplain to the City
of London Police, this trained group
of church volunteers patrol the City
streets talking and listening to people
and offering care and support to those
at risk or in need, from bottles of
water to philosophical discussion.

A broader canvas

[opposite] In preparation for its launch at St Paul's Cathedral, Revd. Dr. Girma Bishaw hosts an evening of information-sharing for The Gratitude Initiative at St Edmund King and Martyr. As the Director and Founder, he hopes that migrant community churches can foster a positive gratitude culture in Britain as a whole.

Salvation with a cup of coffee

[above] The Salvation Army has always had a mission to interact, believing that God has not called Salvationists to be spectators sitting comfortably in their churches but to get out there and engage. Every month, as part of their worldwide 'mobilizing' campaign, staff come out of the International Headquarters and spend a morning giving away free coffee and tea. Initial surprise and reticence can blossom into productive engagement.

Local links

[this spread] Revd. Katharine Rumen's ministry at the parish church of St Giles' Cripplegate is both imaginative and hands-on in its interaction with Barbican residents. Traditional events, such as a well-organised annual book fair, get locals through the door, whilst an innovative approach to regular food bank collections (with supermarket shoppers issued with a list of needed items) results in both impressive donation totals and Revd. Katharine getting to chat informally with donors.

Praying for The City

At 8am on an October Wednesday morning,
Holy Sepulchre is filled to capacity for the
50th anniversary City Prayer Breakfast. As
an annual focus for Christians wishing to
encourage a healthy and sustainable City
through the power of prayer, this event
encourages those working in The Square
Mile to be ambassadors for Christ within
their workplaces.

Evangelical attraction

[right and below] Sunday services at St Helen's Bishopsgate are the best-attended in the City. With its focus on close study of the bible, the church attracts a large following of all ages, particularly students and young City workers, who also flock to its absorbing mid-week discussion groups. It has become a hub for other City churches following its evangelical form of Christian worship.

158

International outreach

[left] Every Sunday, Mandarin-speakers can find a home-from-home for worship at St Peter-upon-Cornhill. As a satellite church of St Helen's Bishopsgate, it successfully welcomes large congregations of young people from Asia who are working or studying in London for a few years.

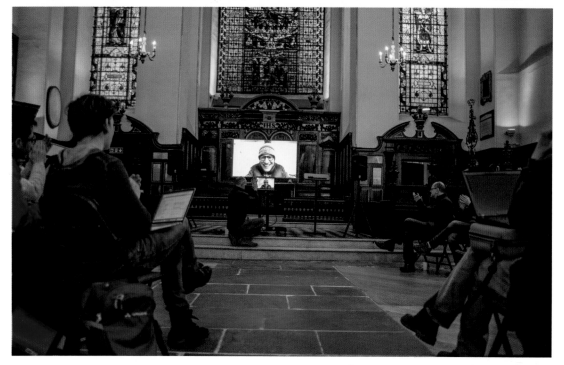

Church planting

[left] Advice about building new congregations is beamed in from remote – and very cold – sources during a teaching session at St Edmund King and Martyr, now the Centre for Church Multiplication. Headed up by Bishop Ric Thorpe, this dynamic initiative aims to regenerate dormant parishes and create new ones nationwide.